The Manifesto Concerning Das

conceived and written
by

Daniel Wilder

Front Cover:

Title: In Waves
Dimensions: 24" X 28"
Medium: Acrylic on Canvas
Series: In Waves: A Neighborhood In Transition

Reference
Pages 27, 28, 30 & 31

Series: In Waves: A Neighborhood In Transition
Copyright © Daniel Wilder 2013

Cover Art and all artwork
Copyright © Daniel Wilder 2014

Registered with the
Library of Congress
United States Copyright Office
Washington, D.C.

All Rights Reserved

Cover Art and paintings
(Plates 1-7)
are signed and dated on the back
by
Daniel Wilder

Registered with the
Library of Congress
United States Copyright Office
Washington, D.C.

The Manifesto Concerning Das
Copyright © Daniel Wilder 2014

Revised
The Manifesto Concerning Das
Copyright © Daniel Wilder 2017

All Content
All Rights Reserved

No part of this publication may be translated, reproduced or transmitted in any form or by any means, such as any electronic device such as PC, PC tablet, smartphone, or mechanical, including film photocopy, digital photocopy, digital copy devices, voice recording, or by any information storage and/or recovery, reclamation system, without permission in writing by the author or assigned agent.

ISBN-13: 978-1494990299

The Manifesto Concerning Das

Printed by
Create Space
an
Amazon.com Company

First print
2014

danielwilder@outlook.com
www.danielwilder.com
www.amazon.com

In Memoriam

My Bother
The quintessential U.S. Marine

David John Fritz
(Bear)
1947-2009

and

My Best Friend

Paul Alexander Kruger
(1956-2017)

Dedications

Dedicated to
Ilene,
My everything

The Manifesto Concerning Das

and

the painting titled:

Flowers For Ilene In The Square
Dimensions: 12" X 12"
Medium: Acrylic on Canvas
Series: In Waves: A Neighborhood In Transition

Plate 1

Plate 1

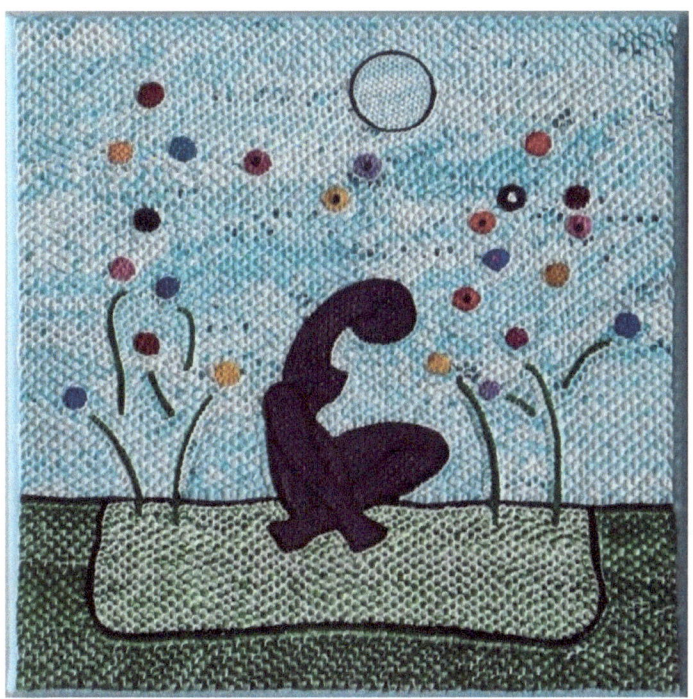

Flowers For Ilene In The Square

Dedicated to
Bear

Plate 2

Title: A Leaf Falls
Dimensions: 20" X 16"
Medium: Acrylic on Canvas
Series: In Waves: A Neighborhood In Transition

Reference
Pages 27 & 29

Plate 2

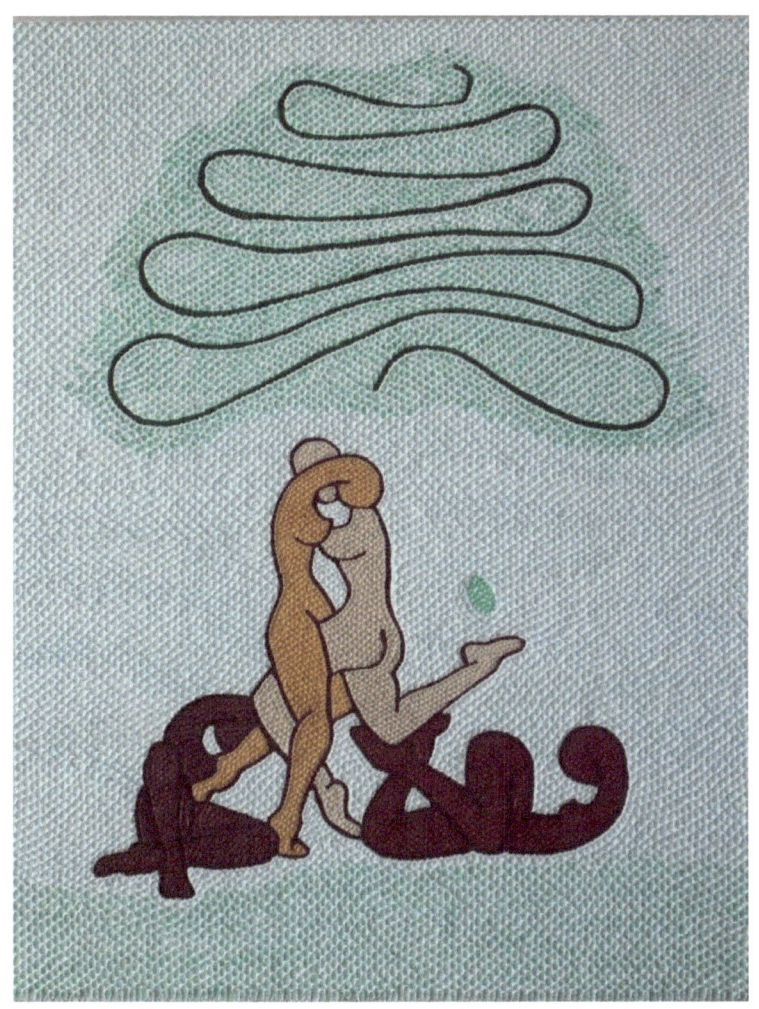

A Leaf Falls

Dedicated to
Paul

Plate 3

Title: Curvilinear Violet
Dimensions: 20" x 16"
Medium: Acrylic on Canvas
Type: Monothematic

Reference
Page 25

Plate 3

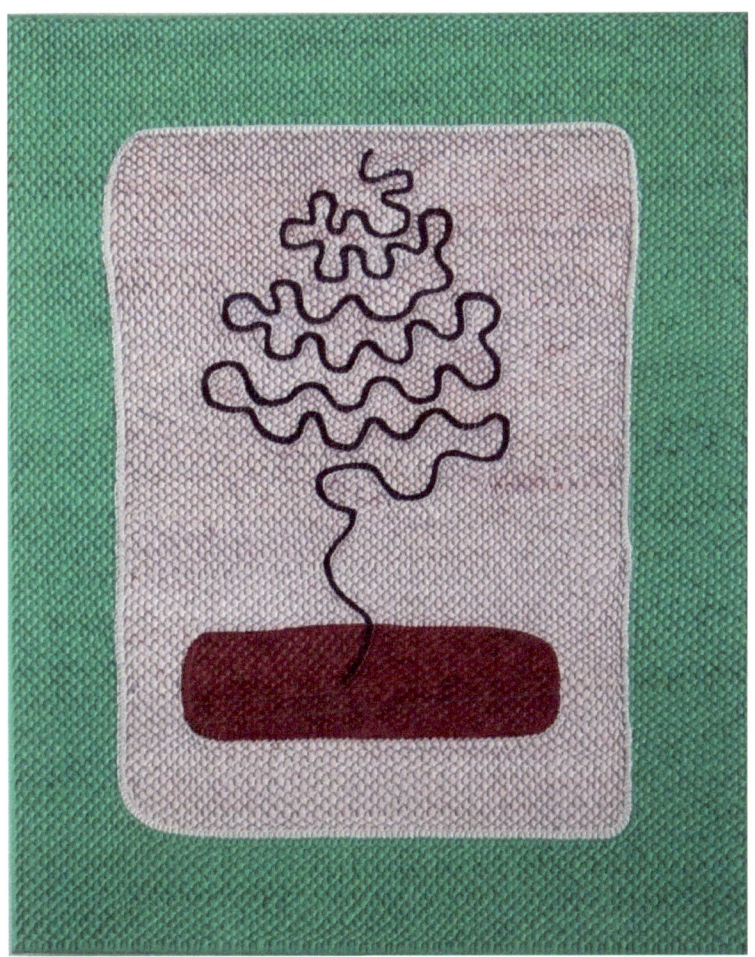

Curvilinear Violet

Acknowledgements

To
Barbara Lea-Kruger
Thank You,

Daniel

Content

In Memoriam	7
Dedications	8
Plates 1-3	9
Acknowledgements	15
The Manifesto Concerning Das	18
Index of terms	21
Endnotes 1-5	22
Plates 4-8	33
Golden Rectangle/Spiral	xliv
Manifestos	xlv
Wilder	xlvi

The Manifesto Concerning Das

As painters continue to search for new methods of pictorial communication, the limitations we place on expressing emotion, reasoned thought, metaphysical or corporeality are bound only by our perception of what their attributes represent and the dimensions in which we believe each exists.

Article I	The evolutionary synthesis of the *Multi-Dimensional Perspective* [1] gives rise to the pictorial language that is *Das* [2].
Article II	As a concept, style and technique Das embraces both structure and order, and has no actual or intrinsic association with the abstract construct or abstract art.
.**Article III**	The following shapes, colors or images are not limited to, nor are they derived from the abstract construct.
	These illustrations include freeform shapes or images depicting the manifestation of nature within *space* [3], 1, 2, 3 and/or 4-dimensional shapes such as geometrical patterns, along with primary, secondary and tertiary colors, color simultaneity, and figurative shapes.
Article IV	Within the *conceptual* [5] framework of Das, a perceived *barrier* [4] becomes the vehicle to transcend a chimerical *boundary* [5].
Article V	Characterized by a meticulous and conscious use of style and technique, Das challenges traditional norms, conventional techniques, and confronts genre profiling.

and The Beat goes on...

Index of terms

1	Multi-Dimensional Perspective	pages	18 & 22
2	Das	pages	18 & 22
3	Conceptual	pages	18 & 31
4	Barrier	pages	18 & 31
5	Boundary	pages	18 & 31

Endnotes 1-5

1 Multi-Dimensional Perspective (2008): The visualization of the interrelationship and coherence between several autonomous dimensions, both spatial and conceptual.

2 Das (2012 CE): An acronym for Dimension and Space. (A): Of or relating to three independent elements; concept, style and painting technique, of which carry the same neological term and idiom. (B): Founded on the Multi-Dimensional Perspective, the primary focus of Das converges on two environments. Das is = to 1, 1, or 3*.

1:Dimension: An entity comprised of five independent dimensions possessing either spatial or conceptual properties; 1: Light, 2: Spectral, 3: Spatial, 4: Fourth, and 5: Style. Dimension is = to 1 or 5*.

Each of the five categorical dimensions is a set consisting of three individual dimensions. Dimension is = to 5 or 15*.

2: Space: An entity consisting of six independent dimensions, two spatial and four conceptual. Space is = to 1 or 6*.

The six interconnected and eclectic dimensions are as follows:

1-1 Light, Dimensions of: In space, two occurrences that take place create the Electromagnetic Field. The first is the motion of an electric field which creates a magnetic field. When these two fields move perpendicular to each other, their point of intersection creates the Electromagnetic Field/Wave.

Within this Electromagnetic Spectrum, visible light is just one of seven fields. Inside this field of visible light is the White Light Spectrum

The wavelength of each color within the White Light Spectrum has a measurement within a range from 380 to 700 nanometers (nanometer = one-billionth of a meter).

*Refer to the notation following the description for Space, (page 31)

In addition, the intensity level of a hue varies from one color to the next. The following compendium provides the wavelength interval of the seven primary hues in the White Light Spectrum:

Red	-	700 ~ 635 nm
Orange	-	635 ~ 590 nm
Yellow	-	590 ~ 560 nm
Green	-	560 ~ 490 nm
Blue	-	490 ~ 450 nm
Indigo	-	450 ~ 430 nm
Violet	-	430 ~ 380 nm

Approximately 44 % of natural visible light emanates from the higher range of warm hues while 56 % of natural visible light generates from the lower range of cool hues. Considering Black or White does not have an Electromagnetic Wavelength, neither is a color/hue. However, one represents the light of day; the other represents the dark of night, or the yin and yang of space.

In addition to sunlight, there are several sources of natural light in our universe, such as reflected light off the moon and from starlight. Contrariwise, from sundown to sunrise the Blue Planet has been illuminated with materials and methods developed by Homo sapiens.

Neanderthal tribes and painters began to light up their lives with fire pits containing combustible materials such as wood, dried moss and/or grasses. Then came bowls filled with flaming animal fat, moss, and twigs, after that tallow/wax lamps, than came candlepower, and after that kerosene/oil lamps, than came natural gas light fixtures, which brings Homo sapiens to the invention of the incandescent light bulb, followed by the fluorescent bulb, halogen lamps and at the forefront the LED bulb.

Although several inventors created models for the incandescent bulb, both Edison, an American inventor, and Swan, a British physicist created prototype bulbs that are still in use.

Consequently, each light source both natural and manufactured, will affect the appearance of pigment colors

differently, especially when two or more light sources are used concurrently.

While having a studio with natural North light (full spectrum white light) is preferable for most studio painters, it is not always possible to obtain such conditions in an urban environment.

In addition to natural light, manufactured illumination is a second source of light which is measured in Kelvins (K), ranging from 2,700 to 6,000 K.

The three analogous dimensions of engineered light are: [a] Artificial, [b] Simulated, [c] Replicated.

[1a]: Artificial: A warm yellow light (2,700 K), emanating from an incandescent bulbs, halogen lamps and/or light emitting diode (LED) bulbs.

[1b]: Simulated: A cool blue light (5,000 K), emanating from fluorescent, compact fluorescent lamps and/or light emitting diode (LED) bulbs.

[1c]: Replicated: A color corrected/full spectrum white light (5,500-6,000 K), emanating from specialized fluorescent, metal-halide lamps and/or light emitting diode (LED) bulbs having a high Color Rendering Index (CRI).

Note: While some painting methods may create the illusion of light, actual light (natural and manufactured) is used to affect the visual appearance of the textural and structural framework within a Das painting.

As the play of natural light changes throughout the day, it affects the visual appearance of the Das style and technique. These effects are evident when a painting is hung on the North or the South wall, and with light emanating from the East (mid-morning) and West (late afternoon).

The effects of natural light on a Das design are most evident and preferable when a painting is hung on the East, West or South wall, and with light emanating from the North. These conditions were established in relation to the approximate latitude and longitude of 39° 55' N / 75° 9' W in Philadelphia, PA..

Subject to an individual's level of sight (20/20 or having visual impairments), the light source (natural and manufactured), along with the distance and angle of view (line of sight) will affect the visual perception (visceral and/or intellectual) of the Das style and technique.

While this could be said of any painting, the effects of natural or electric light may enhance certain textural characteristics of the Das technique, that do not exist in a conventional single medium, 2-dimensional/flat/textural painting.

For example, refer to the painting titled: Curvilinear Violet (Plate 3, page 13). Also, the idea behind this painting, concerning the Dimensions of Light, serves as the origin of the Multi-Dimensional perspective.

1-2 Spectral Dimension: The spectral dimension is derived from or based upon the white light spectrum, which involves manufactured pigment colors comprised of three interlaced dimensions, they are: [a] Hue, [b] Chroma, [c] Value. Considering that neither Black nor White has an Electromagnetic Wavelength, they are not considered to be colors/hues.

[2a] Hue: The visual perception of a color, such as a yellow rose or a manufactured pigment such as cerulean blue.

[2b] Chroma: The visual perception concerning the purity or intensity of a hue. A color's intensity is equal to the percentage of grey added to the hue.

[2c] Value: The visual perception of the lightness or darkness of a hue. A color gets lighter with the addition of light/white pigment, and darker with the subtraction of light/adding black pigment.

1-3 Spatial Dimension: Of or relating to the physical dimensions of a defined space or object. The three most common dimensions used in math or physics to configure a space are [a] 1-Dimensional, [b] 2-Dimensional and [c] 3-Dimensional.

[3a] 1-Dimensional: A point, believed to have no measurable volume, area or length. The point is one of the most contentious of the spatial dimensions.

3b 2-Dimensional: A surface area such as an ellipse that has both height and width.

3c 3-Dimensional: An object or an area which visibly possesses height, width and depth.

1-4 Fourth Dimension: Depending on the school of thought, Science is divided into three branches of study: Formal, Natural and Social. The 4^{th} Dimension is studied under all three branches in three separate fields: (a) Math-Formal Science, (b) Metaphysics-Natural and Social Science, and (c) Physics-Natural Science.

4a Math: A study concerning a 4-Dimensional Hypercube, or {I} Tesseract.

I Tesseract: A small cube within a larger cube, of which the outside corners of the small inner cube connect to the inside corners of the larger outer cube. This 4-dimensional hypercube has eight cells/cubes and consists of sixteen corners/points.

Note: In reference to the painting titled: In Bloom (Plate 6, page 39), the sixteen points of a hypercube (shown as rotating stamens) represent a twisting hyperextended Tesseract (the pistil).

4b Metaphysics: A branch of science/philosophy that studies the nature of humanity, including space and time. The Metaphysical topic in this instance concerns the philosophy pertaining to the temporal parts of {I} Perdurantism and {II} Endurantism. Da Vinci's Vitruvian Man serves as a pictorial representation of both philosophies.

I The Perdurantist contends that the temporal parts of the Vitruvian Man are represented by his extended left arm and leg, which exist in the past. The head and trunk of the body exist in the present while his extended right arm and leg exist in the future.

II The Endurantist maintains that the Vitruvian Man as a whole lives in the now (present) throughout his existence.

Note: Like the Perdurantist and Endurantist portrayed as the Vitruvian Man, the following paintings raise questions concerning the ontology of humanity: In Waves (Front Cover), A Leaf Falls (Plate 2, page xi), Sisyphus (Plate 4, page 35), and Lesbians, Trans And Gays, Oh My! (Plate 7, page 41).

4c Physics: A complex maze leading to several branches of scientific and philosophical study. In this instance, the concern is with the branch of science that studies matter and its motion through space and time.

Two interests in this field involve the bending of space-time, which are known as the geodetic effect and [1] frame-dragging effect. In regards to these effects, all matter affects/alters the fabric of space-time. The following analogy will serve to demonstrate these effects.

1 Geodetic and Frame-Dragging Effects: Imagine a piece of stretched canvas, the size of a performing arts stage, covered with wet paint. A male dancer (earth) is standing in the middle of the canvas. Standing there the canvas starts to bend underneath and around him.

As he begins to perform a perpetual counter-clockwise pirouette, the bend in the paint covered canvas begins to form a large concave cone-like shape that envelops the spinning and now suspended dancer. The spinning motion of the dancer causes the paint/space to swirl in the same direction around the dancer, similar to a vortex.

A female dancer or neo (near earth object) moves onto the canvas and towards the male dancer. As she moves closer to the male dancer, she enters the swirling paint in the concave space. However, the torque of the swirling paint drags the female dancer in a circle around the male dancer.

Like the male dancer, the canvas/space bends around the female dancer, and as she begins to circle the male dancer, the female dancer creates/leaves a concave trail in the canvas/space.

Note: In addition to Geodetic and Frame-Dragging effects, an incorporeal vibration, warp or wave traveling through

space also alters the fabric of space-time. This ripple effect or wave-motion originating from a fixed or variable location creates and transfers energy from one point to another, or simply, a matter of cause and effect.

The Geodetic and Frame-Dragging effects may be equated to recessed or intaglio effects that may be used to create contour lines and images in Das paintings

Subsequently, the series titled: In Waves: A Neighborhood In Transition, has a double entendre. The painting titled: In Waves (front cover) relates to how a wave-motion in space can alter the flow of energy throughout the universe.

When observed from a perpendicular frontal view, the wave-motion is represented by both the human wave and the recessed image of the curvilinear wave, which is located below and to the right of center of the painting. Refer to the painting titled: In Waves (Front Cover).

The painting and the series simultaneously correlate to the ebb and flow of old and new residents who affect the landscape/energy of once-neglected urban neighborhoods.

1-5 Style, Dimension of: Depending on the school of thought, there are at least three interpretations of this term, which concerns the discipline of painting.

1: Style: The pictorial language associated with an artist or group of artists.

2: Style: The intrinsic value of a work/painting.

3: Style: The manner in which three separate dimensions [a] are fused together to create a succession of works that possess some element of consistency.

3a Three Dimensions of style are: Content [I], Design [II], Technique [III].

I Content: Something that is contained within fixed boundaries, such as the text within a book. Content is often described as subject matter, which in turn may refer to the title or theme of the painting.

However, a title or theme may not necessarily pertain to everything that is rendered. In this instance, content pertains to everything that is portrayed in a painting.

In essence, content is the heart and soul of any painting. It is one of the most difficult or challenging dimensions (of style) to bring to realization, as it relies entirely on the execution of the design and technique.

II Design (a.k.a composition)) 1: A drawing/sketch/layout of a garment and its intended appearance. 2: A floor plan for a building. 3: A sketch for a machined mechanism, such as a screw.

In reference to painting: A design is a pictorial syntax or the process that is a key element in bringing the content of a painting to realization. This process involves drawing or making a sketch of the composition, layout or arrangement of the content and the color scheme. The painting technique may also be considered part of the design process.

Note: Along with Geodetic and Frame-Dragging effects (recessed or intaglio), another design element of a Das painting involves the use of figures which often incorporate the "S" curve, a wave like motion and/or elements of the Golden Rectangle/Spiral (refer to Golden Ratio, page xliv).

Taking the use of the Das Technique into consideration, planning the design of the Spatial and Spectral dimensions were key in the depiction of the content of all Das paintings. Refer to the painting titled: A Leaf Falls (Plate 2, page xi), and a detail image (Plate 8, page 43).

III Technique: Of or pertaining to the act of painting. A technique is a method involving the application of paint to a canvas or other suitable surface. There are several techniques that include the skillful and unique use of brushes, paintings knives, dripping, staining, spraying, layering, glazing or various impasto and/or alla prima processes.

Technique and Style are often mistaken to have the same meaning. While technique is one dimension of style, the two terms have dissimilar purposes.

Das Technique: On a corporeal level, the Das technique is a fusion of elements involving the impasto alla prima technique having qualities of intaglio, incised or bas relief effects. These effects are similar to a ripple or the wave effect that occurs in space. For examples of these effects refer to the painting titled: In Waves (front cover), and plates 1-9.

Having little or no under-painting/drawing, this meticulous method of painting achieves the final effects and depiction of content in the initial and only application of paint. The Das technique also allows for the spontaneous use of different Hues.

Using the tip of a painting knife, a single stroke of paint fashions a three-dimensional semi-elliptic shape. This unassuming stroke of paint transforms into a shape having a flat backside and an inward curved front side (plano-concave).

Three or more staggered semi-elliptic shapes create an inverse imbricated design. With the same or similar blade, it is possible to create a crescent shape with similar characteristics.

Refer to the detail image of the painting titled: A Leaf Falls (Plate 8, page 43).

Another aspect of the Das technique concerns illusionism. Refer to the notation following the description for Light.

Also, while it is true that some painters use mixed media or a layering process to produce paintings which create the illusion of being three dimensional, a Das painting having a 3-dimensional surface, creates the illusion of being a flat, 2-dimensional plane.

For an example of this illusion refer to the painting titled: Sisyphus (Plate 4, page 35), or any of the Das paintings.

2 Space: Also known as outer space, cosmos or universe, which may be part of an infinite number of multi-verses.

The National Aeronautics and Space Administration (NASA) established that space begins at an altitude 75 miles above earth's sea level.

Depending on the school of thought there are a least six independent dimensions pertaining to space.

1: Space: A dimension in which all phenomena takes place.

2: Space: The surrounding environment, or an area with fixed or variable spatial dimensions.

3: Space: The distance (a straight line measure) between point (A) and point (B). In the event an additional point (C) is placed anywhere between (A) and (B), the line/distance becomes a variable (warp line~wave or twist) of the fixed distance of (A) and (B).

Refer to the note following Tesseract on page 26 in reference to the painting titled: In Waves (front cover), and the painting titled: In Bloom (Plate 6, page 39).

4: Space: An intangible and infinite dimension where all material objects exist.

5: Space: Often thought of as a vacuum or void.

6: Space: An unfocused feeling, a preoccupied state, or a state of euphoric enlightenment.

3 Conceptual: 1: The formulation of a thought, 2: Consisting of or relating to an idea or concept created in the mind/intellect. 3: (philosophy) An approach to analyzing a theory or concept and involves the study of relative arguments or statements in order to a gain a better understanding, or appreciation of that particular subject.

4 Barrier: 1: Often thought of as something, such as a three-dimensional structure/object, that impedes one's physical movement or journey 2: An imaginary/mental block that restricts physical movement, action or the thought process.

5 Boundary: Often thought of defining the borders of a geographical area or the fixed limitations of something either tangible or imaginary.

1: Boundary: A conceptual boundary can be defined by a single 1-dimensional line having two finite ends, or as one infinite line such as a circle. A circular line may be viewed as the contour line of a 2-dimensional shape, which may be the silhouette of a 3-dimensional sphere.

For example, refer to the painting titled: A Single Curved Line In Yellow (Plate 5, page 37).

Plates 4-8

Plate 4

Title: Sisyphus
Dimensions: 60" X 48"
Medium: Acrylic on Canvas
Completed: 1983
Type: Monothematic

Reference
Page 27 & 30

While living in Fort Lauderdale, FL I often had discussions on Greek Mythology with my older brother David. After one of our talks involving Sisyphus, I began to lay out the composition for this painting directly onto a canvas without completing any preliminary sketches.

Taking a break one evening I stepped onto the balcony outside my apartment/studio. There in the Southern sky loomed the constellation Orion. Of all the myths surrounding Orion the hunter, the one that struck me the most involved his tragic love life. Being almost the total antithesis of Sisyphus, I added Orion to the composition.

A few nights later I went out on the balcony again. This time a waxing crescent moon was awaiting the arrival of the August Blue Moon (the third of four full moons in a three month season). Going back to the canvas I added a large circle with a waxing crescent (blue) moon shape.

The myths involving Sisyphus and Orion are as relevant today as they were when Homer began his Odyssey (c. 600 BCE). A few topics inspired by the two contrasting personalities pertain to: immortals and mortals, life and death, bullyism and abuse of power, transgression and redemption, and things that happen once in a blue moon.

Wilder

Plate 4

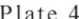

Sisyphus

Plate 5

Title: A Single Curved Line In Yellow
Dimensions: 12" X 10"
Medium: Acrylic on Canvas
Series: Synthesis

Reference
Page 32

Plate 5

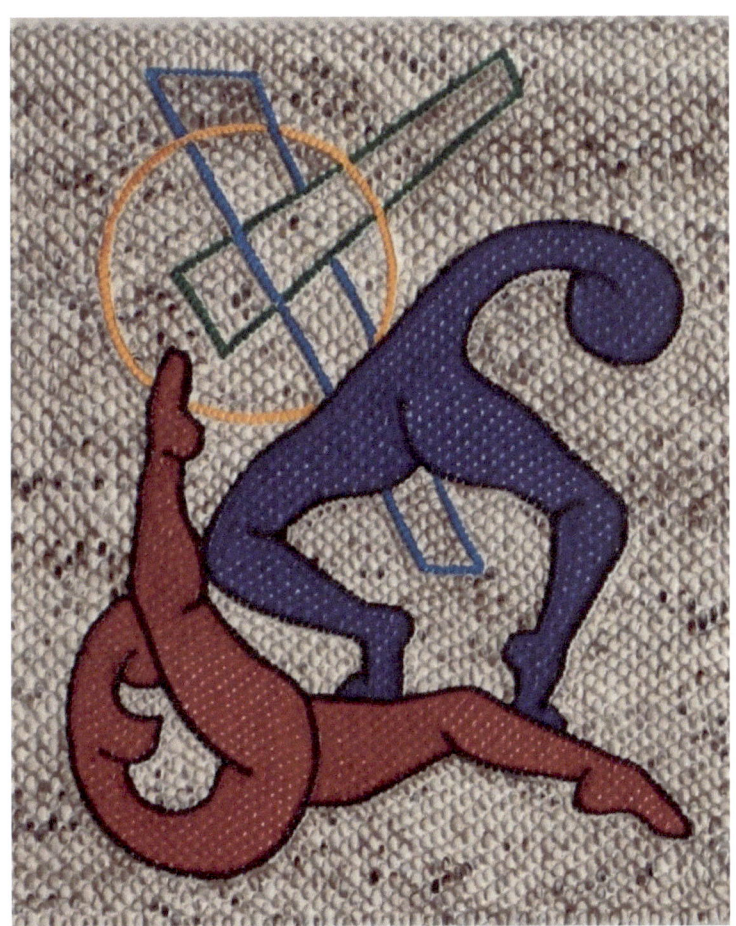

A Single Curved Line In Yellow

Plate 6

Title: In Bloom
Dimensions: 13" X 18"
Medium: Acrylic on Canvas
Series: In Waves: A Neighborhood In Transition

Reference
Page 26 and 31

Plate 6

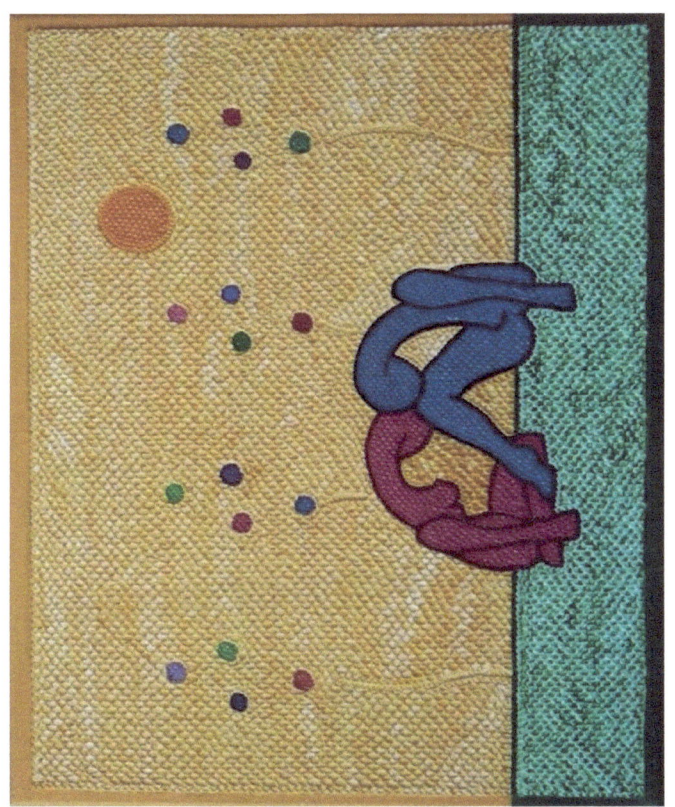

In Bloom

Plate 7

Title: Lesbians, Trans And Gays, Oh My!
Dimensions: 16" X 20"
Medium: Acrylic on Canvas
Series: In Waves: A Neighborhood In Transition

The title for the painting: Lesbians, Trans and Gays, Oh My! was inspired by the movie titled: The Wizard of Oz (1939 CE), produced by Metro-Goldwyn-Mayer Company, Beverly Hills, CA. The movie was based on the novel titled: The Wonderful Wizard of Oz (1900 CE), written by Baum, Lyman Frank.

In addition to confronting antiquated social norms, this painting raises a more pertinent question concerning the ontology of Humankind.

Reference
Page 27

Plate 7

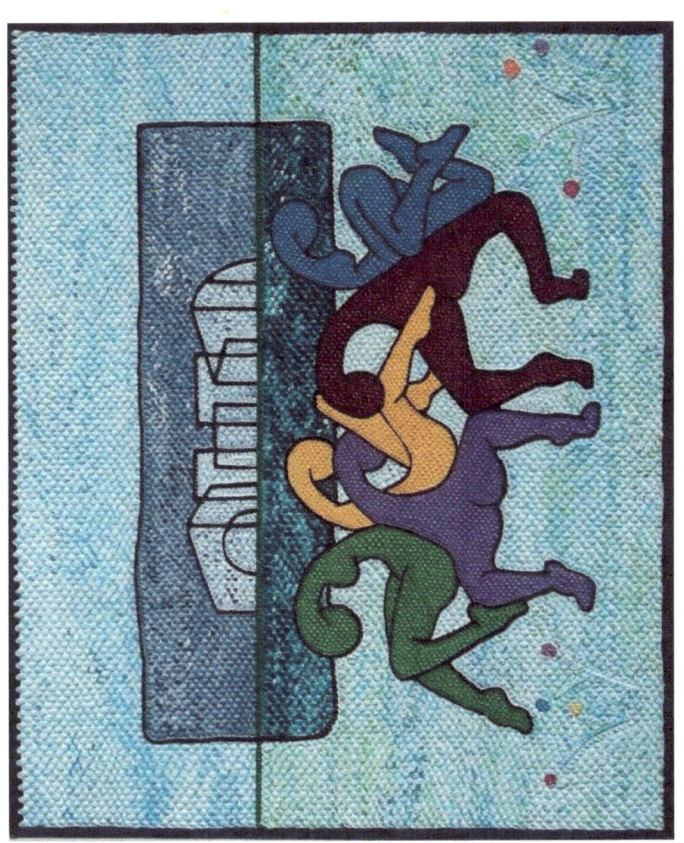

Lesbians, Trans And Gays, Oh My!

Plate 8

Detail Image

Title: A Leaf Falls
Dimensions: 20" X 16"
Medium: Acrylic on Canvas
Series: In Waves: A Neighborhood In Transition

Reference
Page 29 and 30

Plate 8

Detail Image
A Leaf Falls

Golden Rectangle/Spiral

Golden Ratio or Golden Section: The Golden Ratio is a fixed number ~ 1.618 (approximately). The Golden Ratio has been used in mathematics, art, science and architecture since c. 500 BCE.

To find the Golden Ratio of a Golden Rectangle (Diagram a) with dimensions of 13.6" x 22", divide the dividend (22) by the divisor (13.6) to reach the quotient of 1.618 (22 ÷ 13.6 = 1.618). To find the divisor of 8.4, subtract the subtrahend (13.6) from the minuend (22). 22 - 13.6 = 8.4 ~ 13.6 ÷ 8.4 = 1.618, 8.4 ÷ 5.2 =1.618, and 5.2 ÷ 3.2 =1.618. Due to their length, some decimals have been rounded up or down

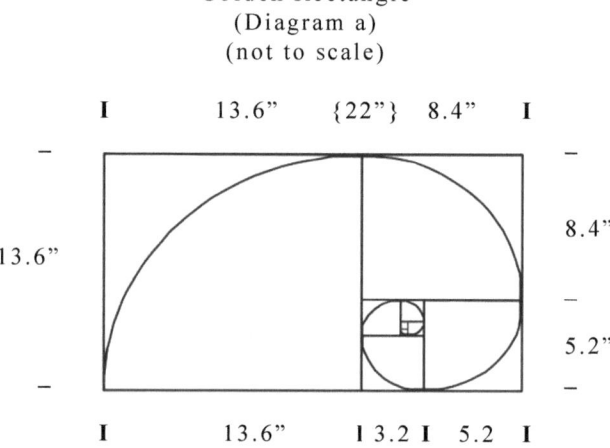

Golden Rectangle
(Diagram a)
(not to scale)

Note: The curvilinear line inside the Golden Rectangle is called the Golden Spiral.

Reference
See notation under Design, page 29.

Borrowed from
Art with an Attitude

Manifestos
and similar text regarding the subject of painting

Balla, Boccioni, Carrà, Rossolo, and Severini. **The Manifesto of the Futurist Painters.** c. 1910 CE.

Benton. **Surrealism.** c. 1925 CE.

Chidish and Thomson. **The Stuckist Manifesto.** 1999 CE

Fontana. **The Manifesto Blanco.** 1946 CE

Fontana and Joppolo. **Spatialism.** c. 1947 CE

Gleizes and Metzinger. **Cubism.** 1913 CE

Huelsenbeck. **Dada Almanac,** 1920 CE.

Kandinsky and Marc. **Der Blaue Reiter Almanac.** 1912 CE

Malevich. **Suprematism.** c. 1913 CE

Mondrian and van Doesburg. **De Stijl.** c. 1914 CE

Rothko and Gottlieb. **Manifesto on Art,** 1943 CE

Van Doesburg, Carlsund, Hélion and Tutundjian. **Concrete Art.** c 1930 CE

Wilder. **Art with an Attitude.** 2015 CE

Wilder

Daniel Wilder is a painter, theorist concerning painting, and author.

Born and raised in Chicago, IL (1951), Wilder grew up on the North Side of the Windy City. As a young teenager, one of his favorite past-times was to ride the EL downtown and visit the Art Institute of Chicago. There he began to learn there was more to the discipline of painting than meets the eye.

In June of 1972, a mutual friend introduced Wilder to Ilene Levy and two months later, they were married. In April of 1973, they moved from their hometown of Chicago to Santa Cruz, Ca. Shortly after their arrival, Wilder enrolled in the Studio Arts and Art History Program at Cabrillo College.

In 1975, Wilder left Cabrillo. Soon after the Wilder's relocated to San Francisco, CA, and during their stay in the city of rolling fog, Wilder was a member of Patricia's Production Company as a set and lighting designer. As such, he developed an interest in how and why natural and artificial light sources affect pigment colors.

The results of this curiosity would come into play over the course of his career as he developed new concepts, and in 1978 created a new impasto alla prima painting technique. Moving to Fort Lauderdale, FL in 1980, Wilder continued to develop his technique and began working with experimental mixed media pieces.

In 1989, the Wilder's moved back to Chi-Town, and in the early 1990's he was a pioneer and advocate for Multi-Sensory Art/Media. In addition to this Wilder began to create experimental pieces using leftover dried paint recovered from glass palettes. He dubbed these works Recycled Acrylics. In 1996, he began research for his treatise titled **Art with an Attitude**.

Having moved to Philadelphia, PA in 2003, Wilder continued to paint and in 2010, he began writing drafts for his Manifesto. In 2013, Wilder completed another series of paintings, and the following year published **The Manifesto Concerning Das**.

In 2014, Wilder finished another series of paintings and in mid-2015 published **Art with an Attitude**. This guidebook to the discipline of painting lends a unique narrative to the origins and evolution of materials, techniques and terms, and their relationship to artists and humanity.

Wilder revised both **The Manifesto Concerning Das** and **Art with an Attitude** in 2017.

www.ingramcontent.com/pod-product-compliance
Lightning Source LLC
Chambersburg PA
CBHW040817200526
45159CB00024B/3009